Pesto

BY LOU SEIBERT PAPPAS
ILLUSTRATIONS BY STEVEN SALERNO

CHRONICLE BOOKS
SAN FRANCISCO

Acknowledgments

With many thanks to a dear long-time friend, Stanford University Italian professor Dina Viggiano, for her expertise on pesto lore, and to Cathie Colson for her fine-tuned logic. Picking basketfuls of fragrant herbs in Casey and Jack Carsten's bountiful herb garden for these recipes was a pleasure and an indulgence.
And thank you to a superb editor, Carolyn Miller.

Copyright © 1994 by Chronicle Books. All rights reserved. No part of this book may be reproduced in any form without written permission from the publisher.

Printed in Hong Kong.

Library of Congress Cataloging-in-Publication Data

Pappas, Lou Seibert.
　　Pesto : fresh herb sauces and spreads / by Lou Seibert Pappas ; illustrations by Steven Salerno.
　　　　p.　cm.
　　Includes index.
　　ISBN 0-8118-0426-7
　　1. Pestos.　I. Title.
TX819.P45P36　1994
641.8'14—dc20　　　　　　　　　　　　　　　93-24860
　　　　　　　　　　　　　　　　　　　　　　　CIP

Cover design: Marianne Mitten and Steven Salerno
Composition: Marianne Mitten

Distribution in Canada by Raincoast Books,
112 East Third Avenue, Vancouver, B.C. V5T IC8

10　9　8　7　6　5　4　3　2　1

Chronicle Books
275 Fifth Street
San Francisco, CA 94103

Contents

- **4** INTRODUCTION
- **7** CULINARY TIPS
- **11** PESTOS
- **33** PESTO PAIRINGS
- **37** APPETIZERS
- **43** SOUPS & SALADS
- **55** SIDE DISHES & LIGHT ENTREES
- **61** ENTREES
- **70** TABLE OF EQUIVALENTS
- **72** INDEX

INTRODUCTION

The commanding fragrance and vibrant flavor of herb pesto awakens the palate in any dish that it touches. The classic Italian pesto—an aromatic uncooked sauce of basil, garlic, olive oil, nuts, and cheese—is wonderfully fresh, brilliant green, and assertive in taste.

Basil pesto originated centuries ago in Genoa, probably influenced by a number of early invaders—including Arabs, Persians, and Byzantines—and is one of the oldest of Italian sauces. In Liguria, the once-great nation of seafarers that launched Columbus, basil reigns supreme. A brilliant grassy green, this herb perfumes the air with a magical scent like no other. Spicy and short-leafed, it spills over window-sills and balconies, flourishing in flower pots and dishpans, tended as lovingly as the scarlet geraniums usually found alongside it. Basil also grows wild on the hillsides,

climbing steep terraces beside vines, fruit trees, and the groves of olive trees that are the source of the fruity oil used as the base for pesto.

Here, basil pesto is omnipresent—so much so that the Ligurians call it their "flag." Made with sweet basil, garlic, pine nuts, olive oil, and pecorino—sheep's milk cheese—it is pounded in a marble mortar with a wooden pestle to create a thick sauce that is used to cloak thick homemade noodles called *trenette*, to lace minestrone or toss with gnocchi, or to gild a corkscrew pasta called *trofie* that is combined with Italian beans and potatoes.

The word *pesto* comes from the verb *pestare*, meaning "to pound or grind," as in a mortar. Traditional Italian cooks always use a mortar to make pesto, preferring the finely minced texture that results.

Today basil pesto has become a favorite flavoring in other countries around the world. Healthy, swift to prepare, and economical, it lends pizzazz to a variety of dishes. And the basic recipe for basil pesto has spawned countless variations using other herbs, each providing its distinct flavor and texture to this versatile sauce.

With fresh herbs readily available in markets with good produce sections and at local farmer's markets, creative cooks are using blenders or food processors to create new herb pestos in a matter of seconds. Herbs also are easy to grow in a kitchen garden: mine boasts fifteen kinds at the moment. Many, like rosemary, oregano, and sage, are perennials and flourish year after year. Others,

such as arugula and several varieties of basils, are annuals easily grown from seeds.

With the ingredients handy, it's a snap to blend a batch of pesto for a taste-tingling accent to innumerable dishes, from appetizers, soups, salads, and entrees to fruit desserts. Pesto makes a superb spread on country bread or toast, a fast topping for a cheese appetizer or pizza, and a power-packed ingredient in salad dressings. The intoxicating aroma that fills the air is only the first of the many rewards of pesto's complexity and depth of flavor.

This book celebrates the honest, earthy goodness of a wide variety of herb pestos by using them in both new and classic ways.

CULINARY TIPS

Wash herbs for pesto under cold running water and gently pat them dry with paper towels. For herbs with large leaves, such as basil, use a salad spinner to dry them thoroughly. Pesto lasts longer when made with herbs that are dry.

Ideally, prepare pesto with freshly picked herbs for the best flavor. Or slip fresh herbs into a plastic bag and place them in the vegetable crisper in the refrigerator. Some herbs, such as parsley, can be stored in a glass of water like a bouquet, covering the container with a plastic bag. Use herbs as soon as possible, or within two to three days.

Pesto may be made in either a blender or a food processor; a food processor usually does a better job. *Note:* When using a blender to prepare pesto, with some models it may be necessary to add the oil along with the herbs.

To store pesto, cover the surface of the sauce with plastic wrap. Or, to prevent the discoloration of Basil Pesto, pour a thin film of olive oil over the surface. Sorrel will retain its pretty green color until it is heated, when it turns an olive drab.

Refrigerate pesto and use it within three or four days. For longer storage, you can freeze it, but don't expect frozen pesto to be as good as freshly made. Pack pesto in small containers, or spoon it into ice cube trays, cover, and freeze it. Be sure to label and date the containers. If you plan to freeze pesto for longer than a few weeks, omit the nuts and cheese when making it and blend them in later. To thaw, place the pesto in the refrigerator and thaw slowly. Avoid defrosting pesto in the microwave, as it can cook the sauce.

Always take a whiff or a taste of the herb you are using to make pesto and feel free to adjust the proportions. Rosemary especially should be used with discretion. Use only the leaves, not the stems, which can be fibrous.

Fresh spinach and flat-leaf, or Italian, parsley are used in many pestos in this book to moderate the intensity of the herbs and to smooth and round out the texture. Flat-leaf parsley has a more intense flavor and smoother texture than curly parsley and is preferred in these recipes.

Use high-quality ingredients: extra-virgin olive oil and freshly grated Parmesan cheese (preferably the imported Italian *parmigiano-reggiano*). Pecorino, a sheep's milk cheese, is often used in Italy. For added flavor, toast almonds, hazelnuts,

walnuts, and pine nuts by placing them in a baking pan and baking them in a preheated 325°F oven for 8 to 10 minutes, or until golden brown. Pistachios can replace more costly pine nuts, as they have a similar sweet, nutty flavor. Select pistachios that are unsalted and roasted.

Pesto proportions are flexible. Feel free to vary recipes to suit your individual taste, and show sensitivity to the particular dish that the pesto will be used in. The amount of cheese, nuts, and oil can be adjusted easily. If a creamier, richer pesto is desired, increase the olive oil. When pesto is paired with pasta, for example, a higher proportion of olive oil is preferable. The amount of oil specified in these recipes is modest in order to make them lower in fat content. If dietary allergies prohibit eating nuts or cheese, they can be omitted.

In addition to the recipes in this book, other herbs and greens, such as watercress, mint, mâche (lamb's lettuce), and mizuna (mild Japanese mustard), can be used in pesto. Fresh ginger and lemongrass are valuable additions to some pestos.

Pesto is a delight for the creative, experimental cook. It can be used to replace fresh herbs in many recipes. It enhances vinaigrettes; salsas; tomato, béchamel, and brown sauces; soups; and stews, and it is a real asset to vegetarian dishes. Add pesto at the end of cooking to retain its freshness, as its taste diminishes with heat.

A fun way to turn a simple supper into a special occasion for family

or impromptu guests is to serve several pestos as toppings for spaghetti, fettuccine, penne, or baked potatoes. Cook a batch of any kind of fresh or dried pasta you prefer. Spoon it onto hot plates and accompany with bowls of different pestos and grated Parmesan cheese. Whole-wheat pasta is particulary good topped with Sun-dried Tomato and Roasted-Garlic Pesto, Olive Pesto, Basil Pesto, or Red Pepper–Almond Pesto. Baked potatoes are excellent topped with any of these and many others, such as Thyme Pesto, Dill Pesto, and Sage Pesto.

Pesto is a lively addition to a sandwich party. For a tasty lunch for guests, offer toast or warm sliced whole-grain or sourdough bread with feta cheese or Brie and several pestos, such as Sun-dried Tomato and Roasted-Garlic, Olive, and Basil, to spread over all.

Two pestos in particular—Olive and Sun-dried Tomato and Roasted-Garlic—keep well for a week or longer when refrigerated and make great staples. After sampling several herb pestos, you'll find your own favorites, which will soon be essential in your kitchen.

Pestos

13 Arugula Pesto

14 Basil Pesto

16 Classic Genoese Pesto

17 Cilantro Pesto

18 Dill Pesto

19 Garlic Chive Pesto

20 Olive Pesto

21 Oregano Pesto

22 Parsley Pesto

23 Provençal Pesto

25 Red Pepper–Almond Pesto

26 Rosemary Pesto

27 Sage Pesto

28 Sorrel-Ginger Pesto

29 Sun-dried Tomato and Roasted-Garlic Pesto

31 Tarragon Pesto

32 Thyme Pesto

Arugula Pesto

The nutty, peppery bite of arugula kindles the taste buds. Add a spoonful of this pesto to green beans, new potatoes, black beans, risotto, and couscous or mix it into a potato salad, a green salad, or the All-Seasons Fruit Bowl on page 50.

1 1/3 cups packed fresh arugula leaves
1/3 cup packed fresh flat-leaf (Italian) parsley sprigs
1/3 cup packed spinach leaves
2 tablespoons walnuts or pistachios
2 large garlic cloves, smashed
3 tablespoons extra-virgin olive oil
2 tablespoons freshly grated Parmesan cheese

IN A BLENDER OR FOOD PROCESSOR, place the arugula, parsley, spinach, nuts, and garlic. Whirl until finely minced. Add the oil and cheese, and process until blended. Transfer to a small bowl, cover, and chill.

MAKES ABOUT 3/4 CUP

Basil Pesto

Over forty types of basil exist, but the sweet, or Italian, large-leafed green basil is classically used for pesto. Other basil varieties such as anise, cinnamon, lemon, and purple or dark opal also work well. Don't expect purple varieties to retain their royal hue upon blending, however; instead they turn a drab brownish-black color.

Basil leaves are fragile: when cut or bruised, they turn black. If refrigerated with too much or too little moisture they also will turn black, wilt, or decay. They do best when stored in the warmest place in the refrigerator.

Traditional pesto is made with more olive oil; the amount of oil in this recipe has been reduced to suit the current preference for foods lower in fat. Once prepared, cover the pesto with a sheet of plastic wrap pressed onto its surface, or pour a film of olive oil over it to prevent oxidation from turning it a muddy brown color on standing. Toss it with fettuccine, spoon it onto a Provençal vegetable soup, dollop it on baked potatoes or omelets, or smear it on sliced red and yellow tomatoes topped with mozzarella cheese. Basil pesto has a particular affinity for lobster, fish, and Mediterranean vegetables such as eggplant, zucchini, bell peppers, and tomatoes. It's a robust, versatile sauce that will embellish a variety of dishes.

2 cups packed fresh basil leaves
3 tablespoons pine nuts, pistachios, or walnuts
2 large garlic cloves, smashed
3 tablespoons freshly grated Parmesan cheese
¼ cup extra-virgin olive oil

IN A BLENDER OR FOOD PROCESSOR, place the basil, nuts, and garlic. Whirl until finely minced. Add the cheese and oil, and process until blended. Transfer to a small bowl, cover, and chill.

MAKES ABOUT ¾ CUP

Classic Genoese Pesto

Purists preferring the traditional Genoese pesto made in a mortar will like this richer version. Pecorino cheese is sharper and saltier than Parmesan and may be difficult to find; romano can be substituted. Some recipes add 2 or 3 tablespoons of soft butter at the end.

2 large garlic cloves
2 cups packed fresh basil leaves
3 tablespoons pine nuts
2 tablespoons freshly grated Italian Parmesan (parmigiano-reggiano) *cheese*
2 tablespoons freshly grated pecorino cheese
1/3 to 1/2 cup extra-virgin olive oil

USING A PESTLE, pound the garlic in a large mortar. Gradually add the basil and nuts and continue pounding until the mixture is well blended. Pound in the cheeses and then the oil, mixing well.

MAKES ABOUT 1 CUP

CILANTRO PESTO

Not everyone loves the tang of cilantro, or fresh coriander, but those who do find it addicting. Cilantro is similar to flat-leafed parsley, but is a lighter green in color and has a distinctive aroma. Use Cilantro Pesto for Mexican dishes such as enchiladas, burritos, tostadas, and beans. Or blend a spoonful of Cilantro Pesto with an avocado and add some chopped green chilies for a quick guacamole. It's also good with garlic-sautéed shrimp or fish, or spooned into pita pockets with tomatoes, cucumber, and feta cheese.

1½ cups packed fresh cilantro leaves
½ cup packed fresh flat-leaf (Italian) parsley sprigs
2 tablespoons pistachios, almonds, or walnuts (optional)
2 garlic cloves, smashed
1 tablespoon fresh lemon or lime juice
3 tablespoons extra-virgin olive oil
2 tablespoons freshly grated Parmesan cheese

IN A BLENDER OR FOOD PROCESSOR, place the cilantro, parsley, nuts, and garlic. Whirl until finely minced. Add the lemon juice, oil, and cheese, and process until blended. Transfer to a small bowl, cover, and chill.

MAKES ABOUT ¾ CUP

Dill Pesto

The cool overtone of dill refreshes seafood, grilled fish, cucumbers, green beans, potato dishes, melon, yogurt dips, sauces, and egg dishes. For a brunch or lunch treat, spread it on bagels topped with lox and cream cheese, or add it to the sweet mustard sauce served with the Swedish pickled salmon dish, gravlax. Russian, Eastern European, Scandinavian, Greek, and Jewish cuisines all love dill. Though it can be difficult for many gardeners to grow, dill is available in generous bunches in the marketplace in summer and fall.

1½ cups packed fresh dill leaves
½ cup packed fresh flat-leaf (Italian) parsley sprigs
2 tablespoons walnuts, pistachios, or pine nuts
2 large garlic cloves, smashed
3 tablespoons extra-virgin olive oil
2 tablespoons freshly grated Parmesan cheese

IN A BLENDER OR FOOD PROCESSOR, place the dill, parsley, nuts, and garlic. Whirl until finely minced. Add the oil and cheese, and process until blended. Transfer to a small bowl, cover, and chill.

MAKES ABOUT ¾ CUP

GARLIC CHIVE PESTO

Garlic chives yield a more gentle taste than do garlic cloves, particularly when served raw. This spread is excellent on smoked salmon and cream cheese–topped bagels, grilled lamb, and lentil or black bean soup, cassoulet, and cheese omelets. A hint: When a head of garlic starts to sprout in your garlic jar, break it apart and plant the cloves in a pot on the windowsill. The young garlic leaves can be used as a substitute for garlic chives.

½ cup packed fresh garlic chives
1 cup packed fresh flat-leaf (Italian) parsley sprigs
½ cup packed fresh spinach leaves
2 tablespoons walnuts or pistachios
1 large garlic clove, smashed
3 tablespoons extra-virgin olive oil
2 tablespoons freshly grated Parmesan cheese

IN A BLENDER OR FOOD PROCESSOR, place the garlic chives, parsley, spinach, nuts, and garlic. Whirl until finely minced. Add the oil and cheese, and process until blended. Transfer to a small bowl, cover, and chill.

MAKES ABOUT ¾ CUP

Olive Pesto

This bold sauce makes a great spread for Italian breads—try it on focaccia, pizzette, and toasted slices of country loaves. Top it with a slice of feta, Asiago, or mozzarella for a hearty sandwich. It also sparks baked fish such as halibut or swordfish steaks. Olive Pesto changes character with the kind of olives you choose, as there is a wide variation in their flavors.

¾ cup pitted black or green niçoise-style olives
½ cup packed fresh flat-leaf (Italian) parsley sprigs
¼ cup packed fresh basil leaves
2 shallots or green onions (white part only), chopped
2 tablespoons walnuts or pistachios
2 large garlic cloves, smashed
3 tablespoons extra-virgin olive oil
¼ cup freshly grated Parmesan cheese

IN A BLENDER OR FOOD PROCESSOR, place the olives, parsley, basil, shallots or green onions, nuts, and garlic. Whirl until finely minced. Add the oil and cheese, and process until blended. Transfer to a small bowl, cover, and chill.

MAKES ABOUT 1 CUP

Oregano Pesto

Oregano grows wild in the hills of Greece and is a natural in Mediterranean cuisine. Try this pesto with grilled eggplant, summer squash, onion rings, and red peppers. It is also good with bean dishes, lamb chops, and chicken. A spoonful is excellent mixed into a Greek salad of tomato and cucumber slices, feta cheese, and Kalamata olives.

1/3 cup packed fresh oregano leaves
3/4 cup packed fresh flat-leaf (Italian) parsley sprigs
3/4 cup packed fresh spinach leaves
2 tablespoons walnut pieces
2 large garlic cloves, smashed
3 tablespoons extra-virgin olive oil
2 tablespoons freshly grated Parmesan cheese

IN A BLENDER OR FOOD PROCESSOR, place the oregano, parsley, spinach, walnuts, and garlic. Whirl until finely minced. Add the oil and cheese, and process until blended. Transfer to a small bowl, cover, and chill.

MAKES ABOUT 3/4 CUP

Parsley Pesto

With its clean, bright flavor and brilliant green color, flat-leaf, or Italian, parsley makes a versatile herb pesto. It is inexpensive, especially when basil is not in its peak season. For an interesting combination if basil is available, replace ½ cup of the parsley with the same amount of basil.

2 cups packed fresh flat-leaf (Italian) parsley sprigs
3 tablespoons pistachios, walnuts, or pine nuts
2 large garlic cloves, smashed
3 to 4 tablespoons extra-virgin olive oil
3 tablespoons freshly grated Parmesan or romano cheese

IN A BLENDER OR FOOD PROCESSOR, place the parsley, nuts, and garlic. Whirl until finely minced. Add the oil and cheese, and process until blended. Transfer to a small bowl, cover, and chill.

MAKES ABOUT ¾ CUP

Provençal Pesto

A quintet of herbs plays counterpart in this intriguing spread, which is perfect for Provençal dishes such as vegetable stews, frittatas, bean salads, grilled lamb, and chicken. It also perks up hearty bean soups and casseroles.

¾ cup packed fresh flat-leaf (Italian) parsley sprigs
½ cup packed fresh spinach leaves
3 tablespoons packed fresh oregano leaves
3 tablespoons packed fresh thyme leaves
3 tablespoons packed fresh tarragon leaves
2 tablespoons pistachios or walnuts
1 large garlic clove, smashed
3 tablespoons extra-virgin olive oil
2 tablespoons freshly grated Parmesan or romano cheese

IN A BLENDER OR FOOD PROCESSOR, place the parsley, spinach, oregano, thyme, tarragon, nuts, and garlic. Whirl until finely minced. Add the oil and cheese, and process until blended. Transfer to a small bowl, cover, and chill.

MAKES ABOUT ¾ CUP

PESTOS

RED PEPPER–ALMOND PESTO

This vibrant scarlet pesto is ideal with Southwest foods such as blue corn chips, chili, quesadillas, tacos, and enchiladas. Also try it as a topping for sautéed corn kernels or polenta.

2 red bell peppers, quartered, cored, and seeded
2 shallots or green onions (white part only), chopped
*¼ cup toasted blanched almonds**
3 large garlic cloves, smashed
¼ cup extra-virgin olive oil
3 tablespoons freshly grated Parmesan cheese or 1 to 2 ounces goat cheese (about 2 to 4 tablespoons)

IN A BLENDER OR FOOD PROCESSOR, place the peppers, shallots or green onions, almonds, and garlic. Whirl until finely minced. Add the oil and cheese, and process until blended. Transfer to a small bowl, cover, and chill.

MAKES ABOUT 1¼ CUPS

**To toast the almonds, preheat the oven to 325°F. Place the nuts in a baking pan and bake for 8 to 10 minutes, or until golden brown.*

ROSEMARY PESTO

Rosemary is one of the great reliables in the garden; it will thrive and multiply in a sunny spot with negligible care. Rosemary Pesto is excellent on lamb and pork, focaccia, and potatoes. Use this herb with discretion, as a little bit goes a long way.

3 tablespoons fresh rosemary leaves
¾ cup packed fresh flat-leaf (Italian) parsley sprigs
1 cup packed fresh spinach leaves
2 tablespoons pistachios or walnut pieces
2 large garlic cloves, smashed
3 tablespoons extra-virgin olive oil
3 tablespoons freshly grated Parmesan cheese

IN A BLENDER OR FOOD PROCESSOR, place the rosemary, parsley, spinach, nuts, and garlic. Whirl until finely minced. Add the oil and cheese, and process until blended. Transfer to a small bowl, cover, and chill.

MAKES ABOUT ¾ CUP

SAGE PESTO

Fresh sage has a more subtle, complex flavor than its dried counterpart and is an important herb in Italian cuisine. This pesto is excellent with pork patties, chops, and roasts. Blend it with pasta, beans, or polenta, or lace a favorite stuffing with it. Sage Pesto is especially good in black bean or lentil soups.

1/3 cup packed fresh sage leaves
3/4 cup packed fresh flat-leaf (Italian) parsley sprigs
3/4 cup packed fresh spinach or basil leaves
2 tablespoons walnuts or pine nuts
2 large garlic cloves, smashed
3 tablespoons extra-virgin olive oil
2 tablespoons freshly grated Parmesan cheese

IN A BLENDER OR FOOD PROCESSOR, place the sage, parsley, spinach or basil, nuts, and garlic. Whirl until finely minced. Add the oil and cheese, and process until blended. Transfer to a small bowl, cover, and chill.

MAKES ABOUT 3/4 CUP

SORREL-GINGER PESTO

Uncooked sorrel retains its stunning emerald green color in this pesto, but when heated it turns olive drab. Sorrel Pesto's decisive sour lemon tang perks up soups such as the Greek avgolemono, black bean, lentil, and summer squash. It also complements baked salmon, halibut, and orange roughy.

1½ cups packed fresh sorrel leaves
½ cup packed fresh flat-leaf (Italian) parsley sprigs
2 tablespoons walnuts
1 large garlic clove, peeled and smashed
¼-inch-thick slice peeled fresh ginger
3 tablespoons extra-virgin olive oil
2 tablespoons freshly grated Parmesan cheese

IN A BLENDER OR FOOD PROCESSOR, place the sorrel, parsley, walnuts, garlic, and ginger. Whirl until finely minced. Add the oil and cheese, and process until blended. Transfer to a small bowl, cover, and chill.

MAKES ABOUT ¾ CUP

Sun-dried Tomato and Roasted-Garlic Pesto

The caramel-like sweetness of sun-dried tomatoes and roasted garlic makes deeply flavorful, vibrant pesto. Slather it on focaccia or toasted sourdough bread, toss it with spaghetti or cold pasta salad, stir it into risotto or black bean soup, or spoon it onto a frittata or Southwestern dishes such as tamales, chiles rellenos, blue corn enchiladas, and chili. This pesto can become addictive and is well worth keeping on hand as a kitchen staple.

Commercial dried tomatoes are available in various styles: flexible and moist like dried apricots; ultra-dry, brittle, and dark reddish brown in color; or packed in olive oil. The moist ones are preferred here.

It's easy to oven-dry your own tomatoes when Romas are at their peak. Preheat the oven to 225°F. Place a rack in a shallow 10- by 15-inch baking pan and cover it with a piece of cheesecloth. Halve the tomatoes and place them cut-side up on the cloth. Bake until the tomatoes are shriveled and somewhat dried but still flexible, like dried apricots. This will take about 8 to 12 hours, depending on their size. Store them in a plastic bag in the refrigerator for up to 2 weeks, or freeze them.

1 whole head garlic
3 tablespoons extra-virgin olive oil
1 cup sun-dried tomatoes (moist style)
1/3 cup packed fresh flat-leaf (Italian) parsley sprigs
2 tablespoons chopped garlic chives or green onion tops
2 tablespoons pistachios or pine nuts
2 tablespoons freshly grated Parmesan cheese

PREHEAT THE OVEN TO 325°F. Slice the top off the head of garlic and place the garlic in a small baking dish; rub it with 2 teaspoons of the olive oil. Bake for 30 to 35 minutes, or until soft. Let cool, then squeeze the garlic puree from its papery wrapper into a bowl. In a blender or food processor, place the garlic puree, tomatoes, parsley, garlic chives or green onion tops, and nuts. Whirl until finely minced. Add the remaining oil and the cheese, and process until blended. Transfer to a small bowl, cover, and chill.

MAKES ABOUT 1 CUP

NOTE: *If you can find only hard and brittle commercial dried tomatoes, soak them in warm water for a few minutes to soften them. Or place them in a microwavable bowl, cover with water, and heat in a microwave for 30 to 60 seconds.*

TARRAGON PESTO

The delicate lemon-licorice taste of Tarragon Pesto is especially good with roast chicken, veal chops, and fish such as salmon, sole, trout, and snapper. It is also superb with sautéed wild mushrooms, omelets, and frittatas. Remember that a little tarragon goes a long way.

1/4 cup packed fresh tarragon leaves
1/2 cup packed fresh flat-leaf (Italian) parsley sprigs
1 1/4 cups packed fresh spinach leaves
2 tablespoons pistachios or pine nuts
2 large garlic cloves, smashed
3 tablespoons extra-virgin olive oil
2 tablespoons freshly grated Parmesan cheese

IN A BLENDER OR FOOD PROCESSOR, place the tarragon, parsley, spinach, nuts, and garlic. Whirl until finely minced. Add the oil and cheese, and process until blended. Transfer to a small bowl, cover, and chill.

MAKES ABOUT 3/4 CUP

THYME PESTO

A few tablespoons of thyme add an intense flavor to this vivid spread. A dollop does wonders for baked potatoes, stuffings, and lentil or bean soup; it also will enhance grilled hamburgers, steak, lamb, and game dishes. Blend with softened butter for a fast herb butter. Try any of the several different varieties of thyme, including lemon thyme with its citrus flavor.

1/3 cup packed fresh thyme leaves
1/2 cup packed fresh flat-leaf (Italian) parsley sprigs
1 cup packed fresh spinach leaves
2 tablespoons pistachios or pine nuts
2 large garlic cloves, smashed
3 tablespoons extra-virgin olive oil
2 tablespoons freshly grated Parmesan cheese

IN A BLENDER OR FOOD PROCESSOR, place the thyme, parsley, spinach, nuts, and garlic. Whirl until finely minced. Add the oil and cheese, and process until blended. Transfer to a small bowl, cover, and chill.

MAKES ABOUT 3/4 CUP

PESTO PAIRINGS

Pesto is the ideal staple for the adventuresome, creative cook. A container of herb pesto in the refrigerator can be the inspiration for any number of interesting dishes. Here are a few possibilities, from appetizers through desserts.

- Shrimp and fresh pineapple appetizer kebabs with a Dill Pesto or Cilantro Pesto and sour cream dip
- Crab cakes with Red Pepper–Almond Pesto or Dill Pesto
- Quesadillas made with Monterey jack cheese, fresh mango slices, and Red Pepper–Almond Pesto
- Italian green beans, Gorgonzola cheese, and Sun-dried Tomato and Roasted-Garlic Pesto

- Grilled eggplant slices topped with melted Fontina and Basil Pesto or Sun-dried Tomato and Roasted-Garlic Pesto
- Soft polenta with sautéed wild mushrooms, diced Roma tomatoes, and Basil Pesto or Sage Pesto
- Roasted red or yellow bell peppers with Arugula Pesto or Garlic Chive Pesto
- Stewed pinto beans with Basil Pesto, Sun-dried Tomato and Roasted-Garlic Pesto, Garlic Chive Pesto, or Arugula Pesto
- Black bean soup with a Sage Pesto, or Red Pepper–Almond Pesto, and yogurt topping
- Sliced cucumbers, yogurt, and Dill Pesto or Tarragon Pesto
- Whole cooked artichokes with a yogurt dip mixed with Basil Pesto or Tarragon Pesto
- Borscht with a dollop of Arugula Pesto mixed with yogurt

- Shrimp-stuffed avocados dressed with Dill Pesto, Tarragon Pesto, or Cilantro Pesto mixed with sour cream or yogurt
- Baked potatoes topped with Thyme Pesto, Garlic Chive Pesto, or Dill Pesto, and your choice of yogurt or sour cream, chopped green or red onions, sliced mushrooms, alfalfa sprouts, and Gorgonzola or shredded Jarlsberg cheese
- Tortellini with Sun-dried Tomato and Roasted-Garlic Pesto, olives, and chopped arugula
- Spoon bread with Sage Pesto or Sun-dried Tomato and Roasted-Garlic Pesto
- Angel hair pasta with scallops and Garlic Chive Pesto or Dill Pesto
- Focaccia topped with Olive Pesto or Basil Pesto and slivers of dry Monterey jack cheese
- Bruschette (garlic-rubbed, olive oil–swathed sourdough or country toasts) with Basil Pesto and fresh diced tomatoes

PESTO PAIRINGS

- Panzanella, the Tuscan salad of tomatoes, cucumbers, and croutons, with a Basil Pesto vinaigrette
- Pita pockets with chicken or lamb strips, dried cranberries, watercress or basil leaves, and a dressing of yogurt and sour cream mixed with Basil Pesto
- Salade niçoise made with grilled sliced tuna, new potatoes, and green beans, topped with a Tarragon Pesto or Dill Pesto vinaigrette
- Lentil salad with feta cheese and Sage Pesto or Provençal Pesto vinaigrette
- Osso buco with Thyme Pesto
- Grilled skirt steaks and grilled vegetables with Sun-dried Tomato and Roasted-Garlic Pesto
- Grilled salmon topped with Basil Pesto, Dill Pesto, or Tarragon Pesto, served with leaf spinach and braised white beans
- Grilled chicken or turkey breast served with red Swiss chard and black beans, and topped with Red Pepper–Almond Pesto or Arugula Pesto
- Honeydew and crenshaw wedges topped with yogurt blended with Sorrel-Ginger Pesto and fresh ginger

Appetizers

38 Pesto Dip with a Vegetable Nosegay

39 Focaccia with Roasted Garlic

42 Leek and Prosciutto Frittata

Pesto Dip with a Vegetable Nosegay

This makes a charming appetizer for a garden party or wedding reception. Arrange the vegetables like a bouquet and tuck parsley sprigs or leaves of arugula or kale around the edges. Pair with a pesto-sparked sour cream dip.

3/4 cup plain yogurt
1/2 cup sour cream
1/2 cup Tarragon Pesto, Basil Pesto, or Dill Pesto
2 teaspoons grated lemon zest
Salt and freshly ground black pepper to taste
Vegetable assortment: mushrooms, cherry tomatoes, sugar peas, radishes, asparagus, fennel sticks, baby carrots, and cauliflowerets
Flat-leaf (Italian) parsley, arugula, or kale for garnish

PLACE A CHEESE STRAINER or cheesecloth-lined sieve over a bowl and spoon in the yogurt; cover and refrigerate for 3 to 4 hours for the liquid to drain and the yogurt to thicken into yogurt cheese.

In a small bowl, mix together the yogurt cheese, sour cream, pesto, lemon zest, salt, and pepper. Spoon the dip into a serving bowl, cover, and chill.

In a shallow wicker basket about 10 inches in diameter, arrange the vegetables in an attractive pattern to form a bouquet and fill in the edges of the basket with parsley, arugula, or kale. Serve the dip alongside.

MAKES 1 1/3 CUPS DIP, ENOUGH FOR 8 SERVINGS

FOCACCIA WITH ROASTED GARLIC

Crusty outside and springy within, focaccia is a beloved Italian bread with a homespun goodness. Its dimpled surface can be embellished with a wide range of toppings, and a coat of pesto varies it even more. Focaccia makes a great accompaniment to soup or salad. Traditionally a flat bread, it can be given a second rising before baking for a lighter texture.

Instead of the roasted-garlic topping, other creative options include shredded prosciutto, sliced sun-dried tomatoes or artichoke hearts, caramelized onions, and such cheeses as mozzarella, Gorgonzola, Parmesan, and ricotta.

1 package active dry yeast
¼ cup warm water (105° to 115°F)
Pinch of sugar or honey
1¼ cups water at room temperature
1½ tablespoons extra-virgin olive oil
3 cups unbleached all-purpose flour
1½ teaspoons salt
Olive oil for brushing
About 1 teaspoon coarse salt for topping
8 roasted garlic cloves (see method, page 30)
Basil Pesto, Sun-dried Tomato and Roasted-Garlic Pesto, Oregano Pesto,
 or Garlic Chive Pesto

IN A LARGE BOWL, combine the yeast and warm water. Stir in the sugar or honey and let stand until dissolved, about 10 minutes. Stir in the 1¼ cups water and the oil. Add 1 cup of the flour and the salt and beat until smooth.

Mix in the remaining flour, ½ cup at a time, until the dough comes together in a ball. Using a heavy-duty mixer, knead with a dough hook for about 8 to 10 minutes. Or, knead by hand on a lightly floured board until smooth and satiny, about 8 to 10 minutes. Place the dough in a lightly oiled bowl, cover, and let rise in a warm place until doubled, about 1½ hours.

Preheat the oven to 425°F. Punch down the dough, turn it out onto a lightly floured board, and knead it for a few minutes to eliminate the air bubbles. Roll out the dough to fit a greased 10- by 15-inch baking pan or a cookie sheet. Or, divide the dough in half and shape into two 9-inch rounds to fit 2 greased 9-inch pie pans. Place the dough in the pan or pans and dimple the dough with your fingers, making depressions about 1 inch apart. Brush with olive oil. Sprinkle with coarse salt and stud with the roasted garlic.

Bake in the middle of the oven for 15 to 20 minutes, or until the focaccia is golden brown. Let cool for 5 minutes in the pan or pans, then turn out onto a rack. Serve warm, cut into slices or wedges, and pass the pesto to spread over the focaccia.

MAKES 1 LARGE RECTANGLE OR TWO 9-INCH ROUND LOAVES

VARIATIONS:

For a lighter, springy bread, let the dough rise until doubled a second time, after placing it in the pan or pans.

For another topping, stud the surface of the dimpled dough with 1½ cups (6 ounces) diced mozzarella cheese and 2 red onions that have been chopped and sautéed in 2 tablespoons olive oil until soft. Brush with olive oil and bake as directed. Serve with Sun-dried Tomato and Roasted-Garlic Pesto or Olive Pesto.

Leek and Prosciutto Frittata

Sautéed leeks and mushrooms flavor an easy egg dish for an easy appetizer, brunch, lunch, or a light supper. It's also excellent cold, topped with a variety of pestos. Remember to cut the leeks lengthwise and wash them thoroughly before slicing to remove all the sand that nestles between the leaves.

2 tablespoons extra-virgin olive oil
2 leeks (white part only), thinly sliced
4 ounces mushrooms, sliced
4 eggs, beaten
Salt and freshly ground pepper to taste
3 tablespoons chopped fresh flat-leaf (Italian) parsley
1 ounce thinly sliced prosciutto, cut into ribbons
¼ cup sun-dried tomatoes (moist style), sliced
3 tablespoons freshly grated Parmesan cheese
Tarragon, Basil, Oregano, Dill, Sage, or Sun-dried Tomato and Roasted-Garlic Pesto

PREHEAT THE BROILER. In a large ovenproof skillet, heat the oil over medium heat and sauté the leeks until translucent, about 5 minutes. Add the mushrooms to the pan and cook 1 minute longer. Pour the eggs into the pan and cook over medium-high heat, without stirring, until the eggs are set and the edges are lightly browned. Sprinkle with the salt, pepper, parsley, prosciutto, tomatoes, and cheese. Slip the pan under the preheated broiler for 2 to 3 minutes to brown the top lightly. Cut into wedges and top with your choice of pesto.

MAKES 8 SERVINGS.

Soups & Salads

44 Pistou Soup

46 Sunburst Seafood Stew

49 White Bean and Pesto Salad

50 All-Seasons Fruit Bowl

52 Couscous with Pesto and Seafood

54 Gingered Yellow Squash Soup

PISTOU SOUP

A classic Provençal dish, pistou can vary with the vegetable bounty of the season (*pistou* is the word for pesto in the niçoise dialect). Peas, fennel, celery, and red bell peppers may also be used in pistou, and squash, sweet potatoes, or yams can stand in for the potatoes. If you don't have time to soak the beans overnight, cover the beans with water in a medium saucepan, bring to a boil, simmer for 2 minutes, then let stand for 1 hour, drain, and cook. For accompaniments, serve pizzette or focaccia, a green salad, and pears and Brie.

1 tablespoon olive oil
1 onion, chopped
2 garlic cloves, chopped
½ cup Great Northern, pinto, or kidney beans, soaked overnight and drained
8 cups homemade or canned low-salt chicken broth
2 potatoes, peeled and diced
2 carrots, peeled and sliced
8 ounces Italian green beans, cut in 1-inch lengths
2 yellow summer squash, sliced
2 leeks (white part only), cut lengthwise and sliced
3 Roma tomatoes, chopped
Basil Pesto, Arugula Pesto, Red Pepper–Almond Pesto, or Sun-dried Tomato and Roasted-Garlic Pesto
Freshly grated Parmesan cheese

In a large, heavy pot, heat the oil and sauté the onion and garlic until they are translucent. Add the soaked beans and broth. Cover and simmer for 30 minutes. Add the potatoes and carrots and simmer for 15 minutes. Add the Italian beans, squash, and leeks and simmer for 10 minutes, or until all the vegetables are tender. Add the tomatoes and heat through. Stir in ¼ cup of the pesto. Ladle into bowls and pass additional pesto and cheese.

Makes 6 to 8 servings

Sunburst Seafood Stew

A pinwheel of coral mussels accented with brilliant green pesto is the centerpiece of each serving of this aromatic fish stew. This recipe was inspired by a spectacular dish created by chef Alain Rondelli, San Francisco chef and restauranteur.

1 tablespoon olive oil
3 shallots, chopped
1 Roma tomato, chopped
½ cup dry white wine
4 cups fish stock, or 2 cups clam broth and 2 cups water
6 saffron strands
2 garlic cloves, minced
1 teaspoon grated lemon zest
1 teaspoon grated orange zest
3 tablespoons chopped fresh flat-leaf (Italian) parsley
16 mussels, scrubbed and debearded
16 shrimp, peeled and deveined
1 dozen bay scallops
Tarragon Pesto, Parsley Pesto, Dill Pesto, or Cilantro Pesto

IN A LARGE SKILLET, heat the oil and sauté the shallots until they are translucent. Add the tomato and sauté for 2 minutes. Add the wine and simmer briskly until it is reduced by one third. Add the fish stock or clam broth and water and boil until the liquid is slightly reduced.

In a mortar, pound the saffron, garlic, lemon zest, orange zest, and parsley together with a pestle. Mix in a little of the hot liquid, return to the pan, and boil briskly for 1 minute. Add the mussels, shrimp, and scallops. Cover and simmer just until the mussel shells open and the shrimp turn pink, about 5 minutes. Ladle into shallow soup bowls, arranging the mussels in a sunburst pattern. Spoon the pesto into the center where the mussel shells meet.

MAKES 4 SERVINGS

NOTE: *When pink singing scallops from the Northwest are available in the shell, they are nice to include.*

SOUPS & SALADS

WHITE BEAN AND PESTO SALAD

This homey, hearty salad can serve as a side dish to grilled fish or chicken or as a light entree for a vegetarian meal. It's a good choice for a picnic or potluck. For a shortcut to soaking the beans, see the introductory note on page 44.

1 cup Great Northern beans or other small white beans, soaked overnight and drained
¼ cup olive oil
2 tablespoons red wine vinegar
1 tablespoon fresh lemon juice
2 teaspoons Dijon mustard
Salt and freshly ground black pepper to taste
⅓ cup Provençal Pesto, Basil Pesto, Dill Pesto, or Oregano Pesto
¼ cup finely chopped red onion
1 cup mixed red and yellow cherry tomatoes, halved
Butter lettuce leaves
Basil sprigs for garnish

PLACE THE BEANS IN A LARGE, HEAVY POT, cover with water, bring to a boil, cover, and simmer until the beans are tender, about 30 to 40 minutes. Drain and let cool slightly.

In a small bowl, stir together the olive oil, vinegar, lemon juice, mustard, salt, and pepper. Place the cooked beans in a medium bowl, stir in the dressing, cover, and chill. Mix in the pesto, onion, and tomatoes. Serve on greens, garnished with basil.

MAKES 6 SERVINGS

All-Seasons Fruit Bowl

Apples and pears are a year-around basis for a snappy mingling of fruits, nuts, and pesto. This colorful medley can serve as a salad accompaniment to brunch or lunch, as a refreshing dessert, or as a partner to a cheese course.

Pesto-Cassis Dressing
¼ cup canola oil
1½ tablespoons raspberry vinegar
1½ tablespoons dry white wine
2 teaspoons cassis syrup*
2 teaspoons Dijon mustard
Salt and freshly ground black pepper to taste
2 tablespoons Arugula Pesto

2 Granny Smith apples, halved, cored, and diced
2 Comice or Bartlett pears, halved, cored, and diced
¼ cup sun-dried tomatoes (moist style or oil-packed), snipped
⅓ cup coarsely chopped arugula leaves or watercress leaves
2 tablespoons pistachios, coarsely chopped

To make the dressing: In a small bowl, blend together the oil, vinegar, wine, cassis syrup, mustard, salt, and pepper. Stir in the pesto, cover, and refrigerate until ready to use.

In a salad bowl, place the apples, pears, tomatoes, and arugula or watercress. Pour the dressing over and mix lightly. Sprinkle with the nuts.

Makes 4 servings

*Cassis syrup is made from black currants and is available in specialty food stores or liquor shops.

VARIATIONS:
> Embellish the salad with slivers of Asiago or dry jack cheese or with nuggets of crumbled Gorgonzola or blue cheese.

Couscous with Pesto and Seafood

Couscous becomes the star of a palate-tingling main-dish salad with the addition of pesto. In this recipe, it's mounded or molded and placed in the center of each serving plate, then surrounded by seafood. For a tabbouleh using smoked poultry, see the variation, below.

1/2 cup regular or whole-wheat couscous
3/4 cup boiling water
1/3 cup Cilantro Pesto or Dill Pesto
2 tablespoons olive oil
1 tablespoon fresh lemon juice
1 teaspoon grated lemon zest
Assorted greens: butter lettuce, red oak leaf lettuce, arugula
8 ounces small cooked shrimp or fresh or thawed frozen crab meat
1 cup cherry tomatoes, halved
Cilantro or dill sprigs for garnish

PLACE THE COUSCOUS IN A MEDIUM BOWL and pour the water over it. Let cool to room temperature. In a small bowl, stir together the pesto, oil, lemon juice, and lemon zest. Pour over the couscous and mix lightly with a fork to separate the grains. Chill.

SOUPS & SALADS

Line 2 serving plates with the greens. Spoon the couscous into mounds on the plates, or spoon it into 2 custard cups, press down to pack the contents, and invert onto the plates. Ring with the seafood and the cherry tomatoes; garnish with cilantro or dill.

MAKES 2 SERVINGS

VARIATION:
Follow the above recipe, replacing the pesto with Parsley Pesto or Arugula Pesto and the seafood with sliced smoked turkey or chicken. Substitute seedless grapes and parsley or arugula sprigs for garnish.

Gingered Yellow Squash Soup

A spoonful of emerald green pesto makes a dazzling accent on this spicy golden squash soup. Crispy flat bread, pizzetta, or focaccia is good served alongside.

1 tablespoon olive oil
1 onion, chopped
2 garlic cloves, minced
1 tablespoon minced fresh ginger
¼ teaspoon ground cumin
¼ teaspoon ground turmeric
⅛ teaspoon freshly ground black pepper
Dash cayenne pepper
1½ pounds (about 5) yellow summer squash, cut into ½-inch-thick slices
2 Roma tomatoes, chopped
3 cups homemade or canned low-salt chicken broth
½ cup plain yogurt
Sorrel-Ginger Pesto, Dill Pesto, or Tarragon Pesto

IN A LARGE, HEAVY POT, heat the oil and sauté the onion, garlic, and ginger until they are translucent. Add the cumin, turmeric, pepper, and cayenne and sauté for 2 minutes. Add the squash, tomatoes, and broth. Bring to a boil, cover, and simmer until the squash is tender, about 15 minutes. Let cool slightly.

In a blender or food processor, whirl the vegetable mixture until smoothly pureed. Blend in the yogurt. Serve warm, at room temperature, or chilled. Ladle into bowls and garnish with a spoonful of pesto.

MAKES 4 SERVINGS

Side Dishes & Light Entrees

56 Pasta with Pesto

57 Risotto with Mushrooms and Sun-dried Tomatoes

59 Polenta with Pesto

60 Grilled Pesto Vegetables

Pasta with Pesto

This famous duo is superb as the star of an informal supper. Accompany with bread sticks or country bread and a mixed green salad with red and yellow cherry tomatoes. Or vary the pasta by adding vegetables or seafood (see below).

6 ounces fettuccine
¾ cup Basil Pesto or Sun-dried Tomato and Roasted-Garlic Pesto
Freshly grated Parmesan or romano cheese

Cook the pasta in a large pot of boiling salted water according to the package directions, or until al dente, about 8 to 10 minutes for dried pasta and 3 minutes for fresh pasta. Reserve 2 to 3 tablespoons of the cooking liquid and drain the pasta. Mix the reserved liquid with the pesto, add to the pasta, and mix to coat. Serve at once on hot plates. Pass cheese to spoon over.

Makes 2 main-course servings

Variations:

Add to the cooked pasta 1 jar (3 ounces) marinated artichoke hearts, drained and halved. Or, toss the pasta with 1 ounce julienned prosciutto and ½ cup cooked small peas, then mix with Basil Pesto and Parmesan cheese to taste. Or, sauté 4 ounces mushrooms in 2 tablespoons olive oil, add to the pasta, and mix with Sun-dried Tomato and Roasted-Garlic Pesto and Parmesan cheese to taste.

RISOTTO WITH MUSHROOMS AND SUN-DRIED TOMATOES

What a wonderful, soul-satisfying dish this is for an informal meal! Creamy risotto is a natural backdrop for a spectrum of pestos. Be attentive in its preparation, though, as the rice must absorb the broth gradually to achieve the right texture. Italian short-grain Arborio rice is a must.

2½ to 3 cups homemade or canned low-salt chicken broth
1½ tablespoons unsalted butter
1½ tablespoons olive oil
2 shallots, chopped
1 cup Arborio rice
1 teaspoon grated lemon zest
4 ounces white mushrooms, sliced
⅓ cup sun-dried tomatoes (moist style), chopped
Salt and freshly ground black pepper to taste
¼ cup freshly grated Parmesan cheese
Arugula Pesto, Tarragon Pesto, Oregano Pesto, or Basil Pesto

BRING THE CHICKEN BROTH TO A BOIL, reduce the heat, and hold it on simmer. In a medium saucepan, heat the butter and oil over medium-low heat, add the shallots, and cook them until they are translucent. Add the rice and cook, stirring, until it is opaque, about 3 to 4 minutes. Add ½ cup of the hot broth and the lemon zest and cook, stirring constantly, until the broth is absorbed. Add another ½ cup broth and the mushrooms and tomatoes, and cook, stirring, until the broth is absorbed. Repeat, adding ½ cup broth 2 more times, stirring until it is absorbed. Add additional

broth as needed until the rice is al dente in the center and creamy on the outside. Season with salt and pepper and sprinkle with cheese. Serve with one or more pestos to spoon on top.

MAKES 2 TO 3 MAIN-COURSE SERVINGS

Polenta with Pesto

Golden polenta makes a beautiful bed for a pesto topping. Pair it with grilled chicken or pork, and accompany it with steamed red Swiss chard, fennel, or sugar snap peas. Though many Italian cooking pros recommend stirring the grains into boiling water, a lump-free technique suggested by chef Joyce Goldstein is to start with cold water.

3 1/2 cups cold water
1 cup polenta (coarsely ground yellow cornmeal)
2 tablespoons unsalted butter or olive oil
1/3 cup freshly grated Parmesan cheese
Salt to taste
Red Pepper–Almond Pesto, Arugula Pesto, Sorrel-Ginger Pesto, or Provençal Pesto

IN A LARGE SAUCEPAN, stir together the cold water and polenta. Cook over low heat, stirring often, until the polenta is thick and the grains are tender, about 30 to 40 minutes. Add more water if the polenta thickens too fast. Stir in the butter or oil and the cheese, and season with salt. Ladle onto hot plates and top with a generous spoonful of pesto. Or, pour the polenta into a pan and let it cool; slice, reheat in a skillet or on a grill, and top with pesto.

MAKES 4 FIRST-COURSE OR SIDE-DISH SERVINGS

VARIATION:

Sautéed shiitake mushrooms or chanterelles are an excellent topping for the polenta and pesto.

GRILLED PESTO VEGETABLES

Grilled vegetables acquire a caramelized flavor that is enhanced with an herb pesto. If you grill a double batch of vegetables, you can serve some at room temperature the next day with a pesto-flavored vinaigrette.

2 tablespoons olive oil
2 teaspoons balsamic vinegar
1 tablespoon fresh lemon juice
1 garlic clove, minced
Freshly ground black pepper to taste
1 tablespoon Basil Pesto, Oregano Pesto, or Thyme Pesto
2 Japanese eggplants, cut into 4 lengthwise slices
1 each red and yellow bell pepper, cut into 2-inch pieces
2 yellow summer squash, cut into 4 lengthwise slices
Basil Pesto, Oregano Pesto, or Thyme Pesto
Fresh basil, oregano, or thyme sprigs for garnish

IN A LARGE NONALUMINUM BOWL, stir together the oil, vinegar, lemon juice, garlic, pepper, and pesto. Add the eggplants, peppers, and squash, and turn to coat. Marinate for 20 to 30 minutes.

Grill the vegetables over medium-hot coals, or place under a preheated broiler 3 inches from the heat for 2 to 3 minutes per side, or until lightly browned and crisp-tender. Arrange the vegetables on plates, top with a spoonful of pesto, and garnish with herb sprigs.

MAKES 4 SIDE-DISH SERVINGS

Entrees

62 Grilled Swordfish, Red Peppers, and Pesto

63 East-West Salmon with Fennel

65 Grilled Sage Chicken with Red Onions, Peppers, and Zucchini

67 Grilled Butterflied Lamb

68 Steak Fajitas with Red Onion–Pesto Sauce

Grilled Swordfish, Red Peppers, and Pesto

Red peppers and arugula add color and a peppery accent to mild-flavored fish steaks. Whether you grill or broil the fish, make sure you don't overcook it—it should be moist and succulent.

1 teaspoon grated orange zest
¼ cup orange juice
1 tablespoon Dijon mustard
2 tablespoons olive oil
⅛ teaspoon freshly ground black pepper
1 tablespoon chopped fresh dill, tarragon, or cilantro
Four 5-ounce swordfish or halibut steaks
2 red bell peppers, halved, cored, seeded, and cut into strips
Arugula Pesto, Dill Pesto, Tarragon Pesto, or Cilantro Pesto

IN A SMALL BOWL, mix together the orange zest, orange juice, mustard, oil, pepper, and chopped herbs. Arrange the fish in a large nonaluminum baking dish and spoon over two thirds of the marinade, coating both sides of the fish. Toss the peppers in the remaining marinade. Marinate the fish and vegetables at room temperature for 30 minutes.

Grill the fish and peppers over medium-hot coals or under a preheated broiler 3 inches from the heat, allowing about 5 minutes per side for the fish and 3 minutes per side for the peppers, or until the fish is barely opaque in the center and the peppers are lightly browned. Serve the grilled fish topped with peppers and a dollop of pesto.

MAKES 4 SERVINGS

East-West Salmon with Fennel

These salmon steaks with a ginger-sesame mahogany glaze were inspired by a meal in a California coastside inn. With their anise overtones, fennel and tarragon complement each other nicely.

1 tablespoon light soy sauce
2 tablespoons rice wine vinegar or white wine vinegar
1 1/2 tablespoons grated or minced fresh ginger
2 garlic cloves, minced
2 teaspoons toasted (Asian) sesame oil
1 tablespoon canola oil
Four 5-ounce salmon steaks or fillets
2 cups chopped fennel (about 2 fennel bulbs)
1 tablespoon olive oil
Salt and freshly ground white pepper to taste
Tarragon Pesto, Dill Pesto, or Cilantro Pesto

IN A SMALL BOWL, mix together the soy sauce, vinegar, ginger, garlic, and oils. Place the salmon in a shallow nonaluminum container and pour the marinade over the fish. Turn to coat both sides and marinate for 1 hour at room temperature. Meanwhile, in a small saucepan cook the fennel in boiling salted water until crisp-tender, about 8 to 10 minutes; drain and toss with the olive oil and salt and pepper. Set aside.

Grill the fish over medium-hot coals or broil under a preheated broiler 3 inches from the heat for about 4 to 5 minutes on each side, or until the interior is just opaque or is still slightly translucent. Place 1 fish steak onto each of 4 hot plates, accompany with fennel, and top with a spoonful of pesto.

Makes 4 servings

Grilled Sage Chicken with Red Onions, Peppers, and Zucchini

Grilled birds waft a heady aroma when gilded with fresh sage and garlic. This is a favorite entree of my good friends—a superb cook and a prolific gardener—when they entertain at their beachfront home. Served just slightly warm, in the Italian mode, the chicken is partnered with a tricolored array of vegetables. Add individual corn puddings, if you like, for a striking presentation.

One 3½-pound chicken
12 large sage leaves (about 2 inches long)
4 garlic cloves, slivered
Salt and freshly ground black pepper to taste
1 to 2 tablespoons olive oil
1 large red onion, cut into ⅜-inch-thick slices
2 medium zucchini, cut into ⅜-inch-thick slices
2 red bell peppers, halved, cored, and cut into strips
Freshly grated Parmesan or romano cheese
Sage Pesto, Basil Pesto, or Tarragon Pesto

WASH THE CHICKEN and pat it dry; reserve the innards for another dish. With poultry shears or kitchen scissors, cut down the back of the bird and remove the backbone. Flatten the chicken by hitting it with a mallet at the breastbone. Slip the sage and garlic under the skin on both sides of the breast and the legs, overlapping the leaves to cover the flesh evenly. Season with salt and pepper. Tuck the drumsticks under the chicken. Grill over

medium-hot coals, turning to cook both sides, allowing a total cooking time of about 35 to 45 minutes, or until the juices run clear when a thigh is pierced. Let sit at room temperature while you cook the vegetables.

Preheat the broiler. Heat the oil in a large skillet over medium-high heat and sauté the onion until it is translucent. Add the zucchini and peppers and sauté until they are crisp and tender. Sprinkle the vegetables lightly with the cheese and place under the broiler for 2 minutes, or until lightly browned. Cut the grilled chicken into serving pieces and accompany with the vegetables. Serve with the pesto alongside.

MAKES 4 SERVINGS

NOTE: *If desired, instead of sautéing the vegetables, brush them lightly with olive oil and grill them over the coals for 2 to 3 minutes per side or until crisp and tender. Sprinkle with cheese.*

Grilled Butterflied Lamb

A butterflied leg of lamb cooks beautifully on the grill, and is superb with a pesto accent. Leftover grilled lamb makes a fine next-day salad with greens and fruits such as seedless red or green grapes, apples, oranges, and avocados. Dress with a vinaigrette mixed with a spoonful of pesto.

1 small leg of lamb, boned and butterflied (about 2 to 2½ pounds)
¾ cup dry red wine
2 tablespoons olive oil
4 garlic cloves, minced
2 shallots, chopped
2 tablespoons fresh rosemary leaves
2 tablespoons chopped fresh flat-leaf (Italian) parsley
Salt and freshly ground black pepper to taste
Rosemary Pesto, Oregano Pesto, or Provençal Pesto

PLACE THE MEAT in a nonaluminum baking pan. Mix together the wine, oil, garlic, shallots, rosemary, parsley, salt, and pepper and pour it over the meat. Cover and marinate in the refrigerator for 6 hours or overnight, turning the meat several times. Remove from the refrigerator 45 minutes before grilling.

Grill the lamb over medium-hot coals for about 8 minutes on each side; the thicker section will be medium-rare, and the thinner ones will be medium. Slice thinly. Overlap and fan the slices on each plate; garnish with a spoonful of pesto.

MAKES 6 TO 8 SERVINGS

Steak Fajitas with Red Onion–Pesto Sauce

This popular Southwestern treat is accompanied with a vibrant salsa made with pesto and red onions. Serve with black beans and guacamole, if you like. For turkey fajitas, see the variation below.

12 ounces flank steak or skirt steak, cut into 1/2-inch-thick slices
1 tablespoon olive oil
2 garlic cloves, minced
1 shallot, chopped
1/4 cup dry red or white wine

Red Onion–Pesto Sauce
1/2 cup chopped red onion
1/3 cup Cilantro Pesto, Red Pepper–Almond Pesto, or Sun-dried Tomato and Roasted-Garlic Pesto

Four 6-inch flour tortillas

Place the steak in a nonaluminum baking dish. Mix together the oil, garlic, shallots, and red wine, and pour over the meat, turning it to coat both sides. Let marinate for up to 1 hour at room temperature.

Meanwhile, make the Red Onion–Pesto Sauce: Soak the chopped onions in ice water to cover for 30 minutes; drain. Stir in the pesto.

Grill the meat over medium-hot coals, or broil under a preheated broiler 3 inches from the heat, for about 5 minutes on each side for medium-rare. Wrap the tortillas in aluminum foil and warm on the grill for 5 minutes.

Slice the meat thinly on the diagonal, divide the slices among the hot tortillas, and top with the sauce.

Makes 2 servings

Variation:
To make turkey fajitas, replace the steak with boneless turkey breast, and use dry white wine in place of red. Grill for about 5 minutes on each side, or until opaque throughout.

Entrees

TABLE OF EQUIVALENTS

The exact equivalents in the following tables have been rounded for convenience.

US/UK

oz=ounce
lb=pound
in=inch
ft=foot
tbl=tablespoon
fl oz=fluid ounce
qt=quart

Metric

g=gram
kg=kilogram
mm=millimeter
cm=centimeter
ml=milliliter
l=liter

Weights

US/UK	Metric
1 oz	30 g
2 oz	60 g
3 oz	90 g
4 oz (¼ lb)	125 g
5 oz (⅓ lb)	155 g
6 oz	185 g
7 oz	220 g
8 oz (½ lb)	250 g
10 oz	315 g
12 oz (¾ lb)	375 g
14 oz	440 g
16 oz (1 lb)	500 g
1½ lb	750 g
2 lb	1 kg
3 lb	1.5 kg

Length Measures

⅛ in	3 mm
¼ in	6 mm
½ in	12 mm
1 in	2.5 cm
2 in	5 cm
3 in	7.5 cm
4 in	10 cm
5 in	13 cm
6 in	15 cm
7 in	18 cm
8 in	20 cm
9 in	23 cm
10 in	25 cm
11 in	28 cm
12 in/1 ft	30 cm

Liquids

US	Metric	UK
2 tbl	30 ml	1 fl oz
¼ cup	60 ml	2 fl oz
⅓ cup	80 ml	3 fl oz
½ cup	125 ml	4 fl oz
⅔ cup	160 ml	5 fl oz
¾ cup	180 ml	6 fl oz
1 cup	250 ml	8 fl oz
1½ cups	375 ml	12 fl oz
2 cups	500 ml	16 fl oz
4 cups/1 qt	1 l	32 fl oz

Oven Temperatures

Fahrenheit	Celsius	Gas
250	120	½
275	140	1
300	150	2
325	160	3
350	180	4
375	190	5
400	200	6
425	220	7
450	230	8
475	240	9
500	260	10

EQUIVALENTS FOR COMMONLY USED INGREDIENTS

All-Purpose (Plain) Flour/Dried Bread Crumbs/Chopped Nuts

¼ cup	1 oz	30 g
⅓ cup	1½ oz	45 g
½ cup	2 oz	60 g
¾ cup	3 oz	90 g
1 cup	4 oz	125 g
1½ cups	6 oz	185 g
2 cups	8 oz	250 g

Whole-Wheat (Wholemeal) Flour

3 tbl	1 oz	30 g
½ cup	2 oz	60 g
⅔ cup	3 oz	90 g
1 cup	4 oz	125 g
1¼ cups	5 oz	155 g
1⅔ cups	7 oz	210 g
1¾ cups	8 oz	250 g

Long-Grain Rice/Cornmeal

⅓ cup	2 oz	60 g
½ cup	2½ oz	75 g
¾ cup	4 oz	125 g
1 cup	5 oz	155 g
1½ cups	8 oz	250 g

Dried Beans

¼ cup	1½ oz	45 g
⅓ cup	2 oz	60 g
½ cup	3 oz	90 g
¾ cup	5 oz	155 g
1 cup	6 oz	185 g
1¼ cups	8 oz	250 g
1½ cups	12 oz	375 g

Grated Parmesan/ Romano Cheese

¼ cup	1 oz	30 g
½ cup	2 oz	60 g
¾ cup	3 oz	90 g
1 cup	4 oz	125 g
1⅓ cups	5 oz	155 g
2 cups	7 oz	220 g

INDEX OF RECIPES

Pestos 11-36

 Arugula Pesto 13
 Basil Pesto 14
 Classic Genoese Pesto 16
 Cilantro Pesto 17
 Dill Pesto 18
 Garlic Chive Pesto 19
 Olive Pesto 20
 Oregano Pesto 21
 Parsley Pesto 22
 Provençal Pesto 23
 Red Pepper–Almond Pesto 25
 Rosemary Pesto 26
 Sage Pesto 27
 Sorrel-Ginger Pesto 28
 Sun-Dried Tomato and Roasted-Garlic Pesto 29
 Tarragon Pesto 31
 Thyme Pesto 32

Appetizers 37-42

 Pesto Dip with a Vegetable Nosegay 38
 Focaccia with Roasted Garlic 39
 Leek and Prosciutto Frittata 42

Soups & Salads 43-54

 Pistou Soup 44
 Sunburst Seafood Stew 46
 White Bean and Pesto Salad 49
 All-Seasons Fruit Bowl 50
 Couscous with Pesto and Seafood 52
 Gingered Yellow Squash Soup 54

Side Dishes & Light Entrees 55-60

 Pasta with Pesto 56
 Risotto with Mushrooms and Sun-Dried Tomatoes 57
 Polenta with Pesto 59
 Pesto Vegetables, Grilled 60

Entrees 61-69

 Swordfish, Red Peppers, and Pesto, Grilled 62
 East-West Salmon with Fennel 63
 Sage Chicken with Red Onions, Peppers, and Zucchini, Grilled 65
 Butterflied Lamb, Grilled 67
 Steak Fajitas with Red Onion–Pesto Sauce 68